LEICESTER
HISTORY TOUR

First published 2017

Amberley Publishing
The Hill, Stroud,
Gloucestershire, GL5 4EP
www.amberley-books.com

Copyright © Stephen Butt, 2017
Map contains Ordnance Survey data
© Crown copyright and database right
[2017]

The right of Stephen Butt to be
identified as the Author of this work
has been asserted in accordance with
the Copyrights, Designs and Patents
Act 1988.

ISBN 978 1 4456 6664 8 (print)
ISBN 978 1 4456 6665 5 (ebook)

British Library Cataloguing in
Publication Data.
A catalogue record for this book is
available from the British Library.

Origination by Amberley Publishing.
Printed in Great Britain.

INTRODUCTION

A history tour of Leicester is a walk through 2,000 years of history. It is not only an account of wars and monarchs or the activities of the landed gentry, but it is also the story of the remarkable individuals, each with their own skills and determination, who together have made Leicester the city it is today.

The history of any place in any time is dynamic and ever-changing. Apparently sound decisions taken one day may be proved nonsensical the next. Politicians and civic leaders may be exalted in one decade but forgotten in the next, or it may take time for their contribution to the city to be fully realised and understood. The events of our own time prove how transient some beliefs and ideas are, whereas others can change the world forever.

With the exception of London, there are very few counties that have such a rich resource of historical documentation than Leicestershire. At the heart of this well-studied area is the city of Leicester, home to the largest history department of any English university. Here is a city that, in comparison with other settlements of similar size and age, lacks the trappings of grandeur but enjoys a rich unbroken heritage that stretches across two millennia from before the arrival of the Romans under Emperor Claudius in AD 43.

The underlying uniform pattern of the Roman settlement influenced the layout of the medieval town of Leicester and is still to be seen today, suggesting that there was some continuity of occupation in the time between the end of Roman occupation and the beginning of the Saxon settlement in the late seventh century. The town walls have long gone, but it is still possible to see where they once stood, and to stand where the gates of the town were opened to welcome merchants and shut to repel invaders. East Gates, Southgate and Northgate are still on the map, as are the echoes of the Danish past, as in Churchgate and Gallowtree Gate.

Despite constant redevelopment since the early Victorian era, some examples of structures from earlier centuries have survived.; not only several fine medieval

churches, but also the legacy of the Wyggeston family represented by Wyggeston's House, the Chantry House in the Newarke and St Martin's House, originally the Wyggeston Boys' School; and of the Earls of Leicester in the form of Leicester Castle, and Trinity Hospital.

Willam Wyggeston, arguably Leicester's greatest benefactor, was a young man when the body of Richard III was brought back to the town after his defeat at the Battle of Bosworth in 1485. It would be surprising if he, along with many residents, did not witness this event first-hand. The old inn where Richard spent the night before the battle has gone, but we know where it stood and what it looked like. The king now lies in the cathedral, his previous burial place in the Greyfriars, close by in the shadow of the cathedral spire, and some arches still remain of the Church of St Mary in the Newarke where he lay in state.

Leicester has a rich architectural legacy. Isaac Barradale is regarded as one of England's finest arts and crafts architects. Examples of his work still stand proud in the city centre and in the suburbs. Buildings designed by Ernest Gimson, Edward Burgess, Arthur Wakerley and Stockdale Harrison are still in everyday use, many having found a new role in the life of the modern city. There may also be a few surprises in this tour of the city's past, including a concrete multistorey car park and a telephone exchange, but these are included because of their significance in Leicester's long history.

Leicester is at the heart of England, near to the geographical centre of the country, on a main railway route, only 90 minutes from St Pancras International and well-served by the motorway network, but it rarely has a national prominence in economic, political or cultural news. A notable exception was the discovery of the remains of Richard III in 2012, an event that, with the subsequent debate over where the monarch should be re-interred, gave Leicester great prominence worldwide and rejuvenated the local tourist industry.

Yet there are many other historical figures connected with Leicester: authors, writers, playwrights, actors, comedians, businessmen, athletes and politicians. Each has left his or her mark on the city, perhaps at times unnoticed by local people and visitors alike because, for the most part, Leicester hides its heritage just as it hides its best buildings.

ACKNOWLEDGEMENTS

As well as the standard and classic texts about Leicester, many local historians have helped in my search for photographs that capture the essence of city's past, and have provided vital snippets of information. In particular, I would like to thank Robert Smith and Dennis Calow, BBC Radio Leicester and Micky Sandhu of Everards Brewery Ltd for their various contributions.

I have drawn on material in Leicester City Council's Conservation Area Character Appraisals, which are an excellent source of detail about the history and heritage of specific areas of the city, and I would also like to acknowledge the Transactions of the Leicestershire Archaeological and Historical Society, which is a rich source of reliable information covering over 150 years of fine scholarship.

KEY

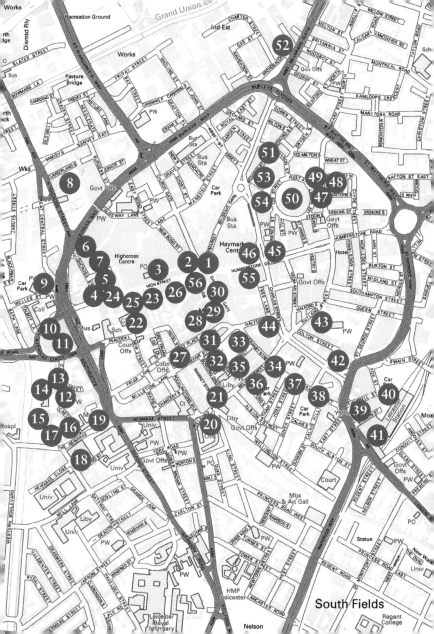

1. THE CLOCK TOWER

The clock tower stands just outside the medieval east gate of the town where five ancient streets meet. It was built in 1869 by local architect Joseph Goddard who won a competition to find the best design. Facing outwards from the tower are statues of Portland stone depicting four 'sons' of the town: Simon de Montfort, William Wyggeston, Thomas White and Gabriel Newton.

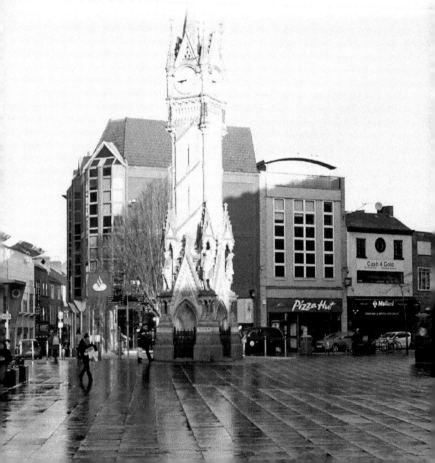

2. THE EAST GATES COFFEE HOUSE

The coffee house was built by Edward Burgess, designer of six of the twelve coffee houses operated by Leicester's temperance movement, which was a powerful cultural force in the late nineteenth century. It was opened by the Duchess of Rutland in June 1885 and was sold by the Leicester Cocoa and Coffee House Movement in 1921.

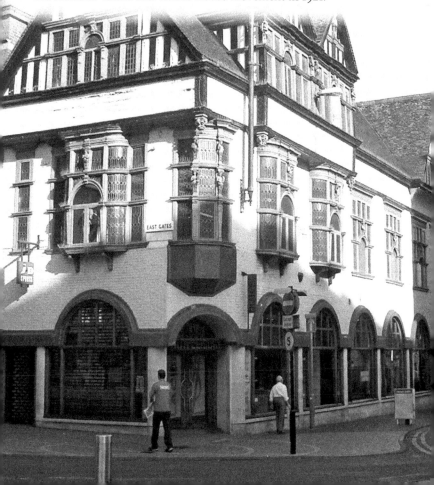

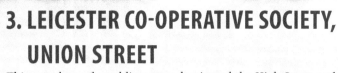

3. LEICESTER CO-OPERATIVE SOCIETY, UNION STREET

This popular and rambling store dominated the High Street and was a favourite shopping focus for local people for many years. Designed by Thomas Hind, it opened on 10 November 1894. Several extensions were added in later years. The frontage was retained when the Shires shopping centre, now the Highcross Centre, was developed in 1989.

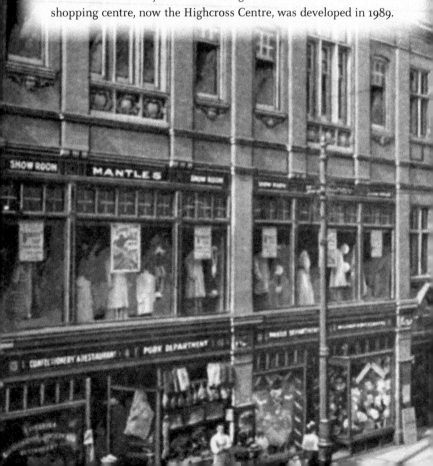

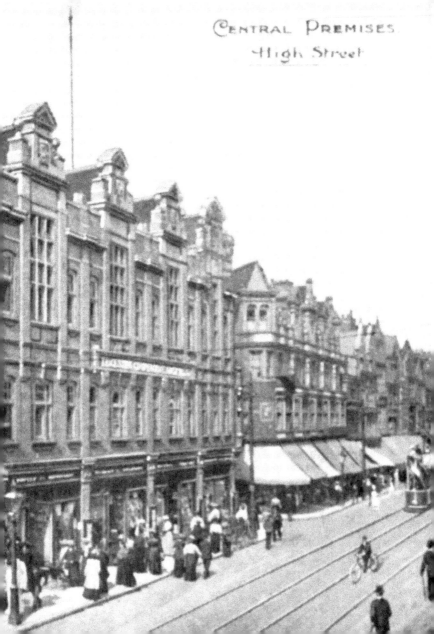

Central Premises
High Street

4. THE HIGH CROSS

This was the site of a very ancient market at the exact centre of the old town and where important routes converged. There was a cross here as early as 1278 when records indicate it was repaired. The last remaining pillar now stands nearby at the corner of Jubilee Square and was repaired in 2016 after being damaged. This is John Flower's lithograph dated 1826.

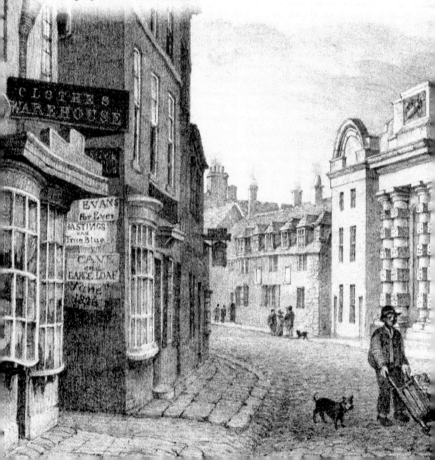

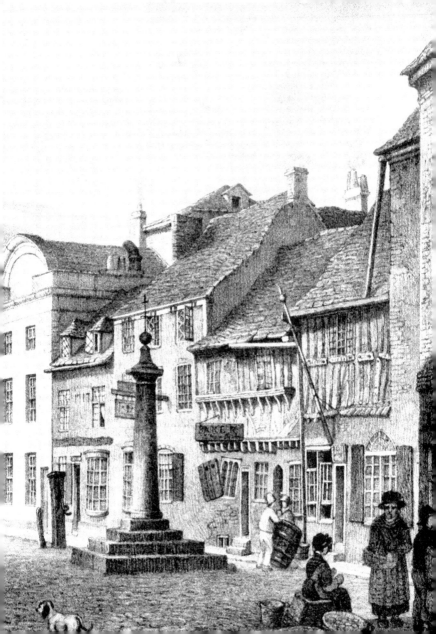

5. THE BOROUGH GAOL

This rare photograph shows the old gaol being demolished in around 1897. There are signs of a market taking place, perhaps a remnant of the old High Cross Market. In its place, several small industrial premises were constructed, occupied at various times by William Sutton Ltd., tanners, and the Glenfield Hosiery Company. One small column of the old gaol's stonework still exists as part of the retaining wall of a Victorian shop.

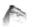

6. THE BLUE BOAR INN

This famous and very ancient hostelry, which was built in the fifteenth century, is where Richard III spent his last night before the Battle of Bosworth on 20 August 1485. He chose to stay here because the castle was falling into disrepair. The inn was demolished in 1836 when a new pub of the same name was built nearby. Appropriately, where the old inn stood is now a Travelodge.

7. THE ELIZABETHAN GRAMMAR SCHOOL

The school was founded by Thomas Wyggeston and was originally housed in the old church of St Peter, which was demolished in 1573. Stone from the church was used to build the school, and Elizabeth I was one of a number of wealthy benefactors listed on a plaque on the side of the building. In 2008 it was refurbished and integrated very imaginatively into the new Highcross Centre.

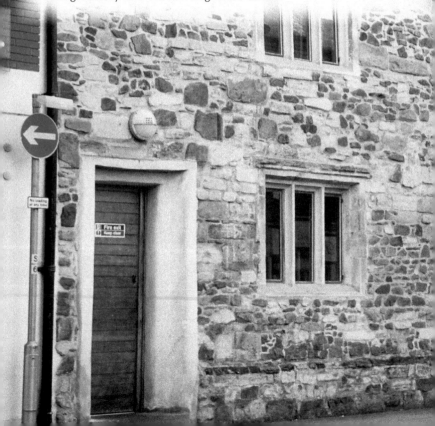

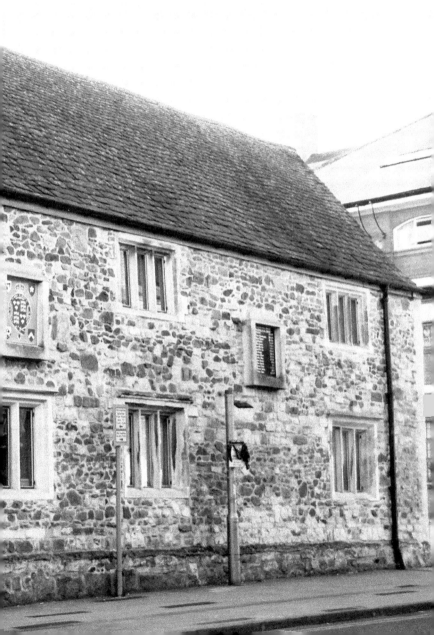

8. ALL SAINTS' CHURCH

One of Leicester's oldest churches stands on the ancient road that led north out of Leicester. The earliest part dates to the twelfth century. In 1583, the assizes were held because of several outbreaks of the plague. In the twentieth century, congregations declined and, having been declared redundant, it is now in the care of the Churches Conservation Trust.

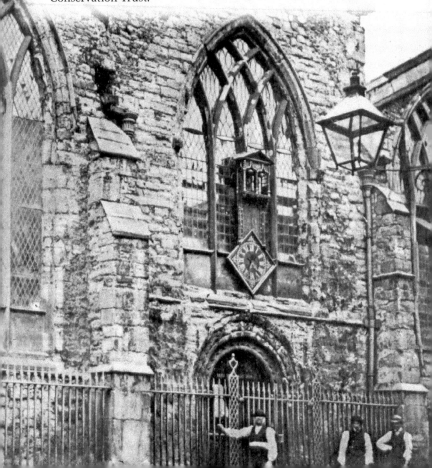

9. THE JEWRY WALL AND ST NICHOLAS CHURCH

Why this large Roman structure is called the Jewry Wall is still not known for certain but it does not appear to be connected with either Jews or juries. Close by is Leicester's oldest place of worship, which has Roman material within its structure. A church existed here before the present building, which suggests that this has been a place of Christian worship for at least 1,400 years.

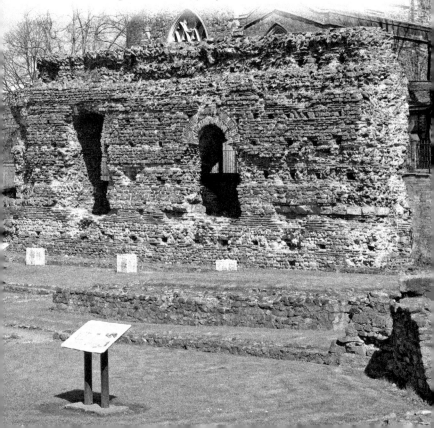

10. REDCROSS STREET

The Holiday Inn now stands on the site of this terrace of little shops and dwellings, once a familiar sight in Leicester. The cathedral spire can be seen in the background. The entire area was cleared in the 1960s to make way for the Central Ring and St Nicholas Circle. The street gained its name from the 'reed cross' that once stood here and marked another of the town's markets.

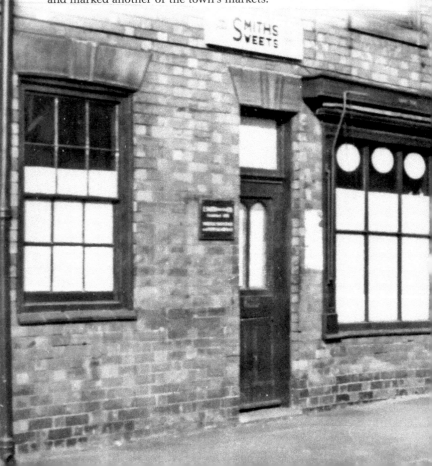

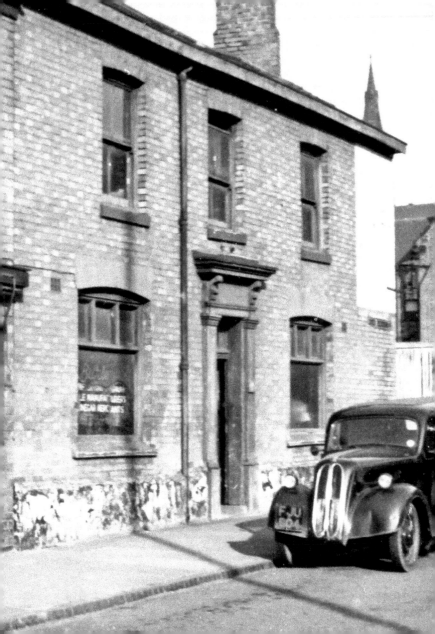

11. APPLEGATE STREET

This was a continuation of Redcross Street and is now part of the St Nicholas Circle traffic system between Bath Lane and Talbot Lane. Here, Mr Glover stands outside his well-stocked shop. Next door was Ferneyhough & Sons, printers. These shops faced towards where the Holiday Inn now stands.

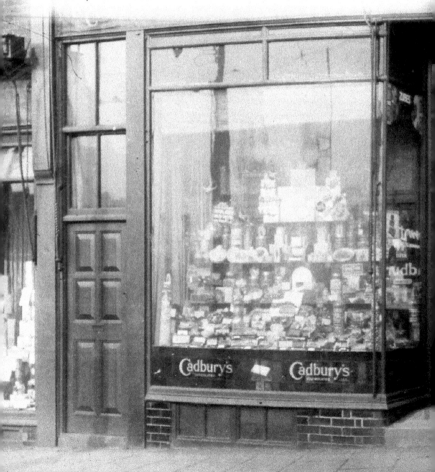

...OVER **TOBACCONIST.**

7

DAY

Chocolates **Cigarettes**

CRAVEN PLAIN

FRY'S KISS PLAIN

PARK DRIVE

CRAVEN A

Rowntree's

Cadbury's

12. ST MARY DE CASTRO

St Mary de Castro (literally 'of the castle') was founded in 1107 by Henry I. It is thought that Geoffrey Chaucer married Philippa de Roet here, a lady-in-waiting to Edward III's queen, Philippa of Hainault, and sister of Katherine Swynford, who became the third wife of John of Gaunt. The Parliament of Bats was held in Leicester Castle in 1426 when the young Henry VI was knighted here in the church. The spire was removed in 2014 because it was unsafe.

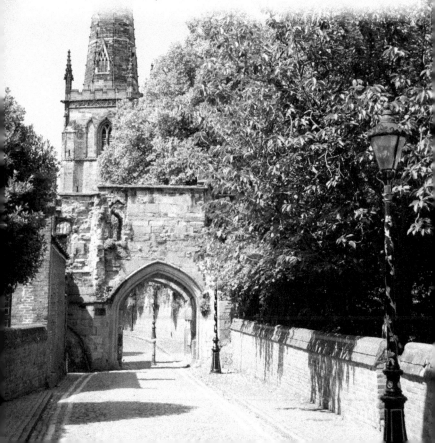

13. THE JUDGES' LODGINGS (CASTLE HOUSE)

These two linked medieval houses and another of the Georgian period together formed part of the lodge of the porter guarding the entrance to Castle Yard. Later, it provided accommodation for high court judges visiting the city. Human burials were discovered during refurbishment work in around 1750, suggesting that the site was either part of the burial ground of St Mary de Castro or possibly a place where the bodies of those executed on Castle Green had been interred.

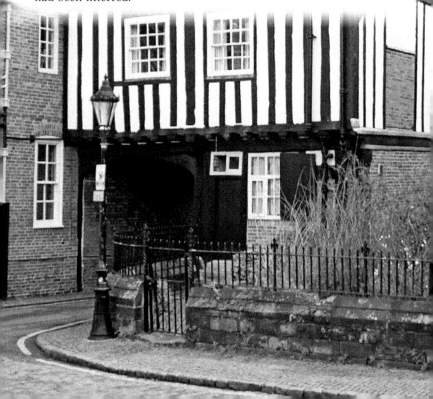

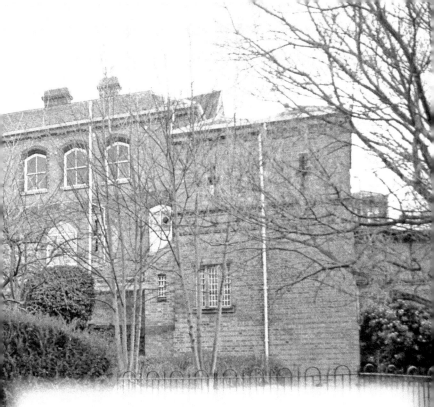

14. LEICESTER CASTLE

Despite its seventeenth-century exterior, Leicester's castle was probably built just after the Norman Conquest, at first as a wooden bailey on a motte, which has survived and is accessible today via a footpath. The great hall has one of only three Norman arched ceilings in Britain and is the oldest aisled and bay-divided hall in Europe. John of Gaunt lived here and welcomed a young Richard II, who returned years later as a prisoner before his deposition by Gaunt's son, Henry IV. The castle now accommodates the Business School of De Montfort University.

15. THE TURRET GATEWAY

This was the gateway between the castle precincts and the Newarke or 'New Work'. Part of the original medieval walls can be seen in the nearby gardens with the scars of battle still evident in the stonework. In 1645, Prince Rupert led a fierce attack on Leicester with overwhelming Royalist forces and this area was the scene of fierce fighting. Leicester's famous witch, Black Annis, is said to lurk here and pounce on those who pass by at midnight.

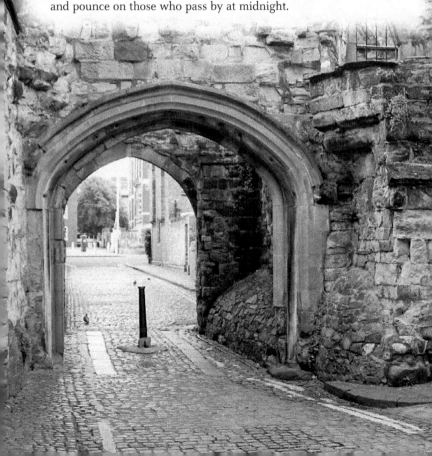

16. WYGGESTON'S CHANTRY HOUSE

Built by wealthy wool merchant and Mayor of Leicester William Wyggeston in 1512, this house was a residence for two priests who served at the chantry Wyggeston founded in the nearby Collegiate Church of the Newarke. The building is now part of the Newarke Houses Museum. The Wyggeston arms were formerly displayed above the front entrance and can now be seen inside the building.

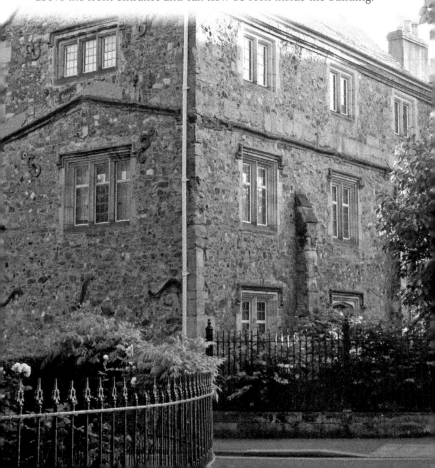

17. TRINITY HOSPITAL

Trinity Hospital was founded in 1331 by Henry, 3rd Earl of Lancaster and Leicester. His son, the 4th Earl, as Duke of Lancaster, extended it as part of the religious foundation centred on the Church of St Mary of the Annunciation in the Newarke. It has been rebuilt on several occasions and is now part of De Montfort University. The chapel at the east end of the hospital is original.

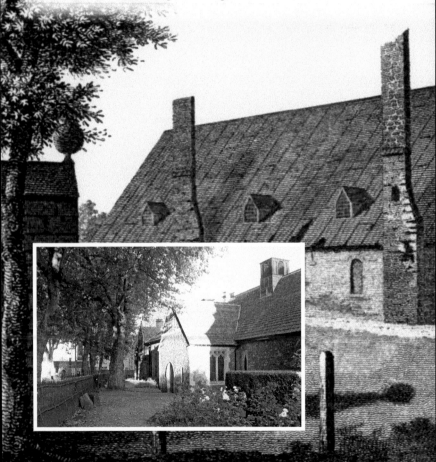

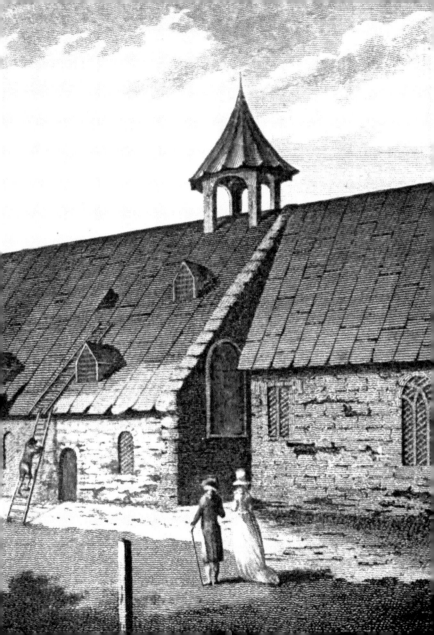

18. THE HAWTHORN BUILDING

Built for the Leicester Municipal Technical and Art School and extended three times between 1890 and 1937, the Hawthorn Building is still at the centre of education in Leicester, being part of De Montfort University. Under the west wing lie arches from the Church of St Mary of the Annunciation where the body of Richard III was displayed following the Battle of Bosworth. This historic event and other scenes from the town's past were acted out in the Leicester Pageant of 1932 with costumes designed by the School of Art.

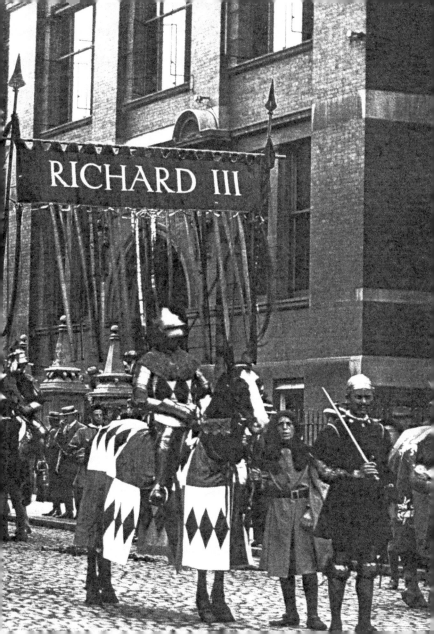

19. THE NEWARKE GATEWAY

This was the second entrance to the Newarke and was built in the early years of the fifteenth century, designed to impress rather than as a fortification. The Newarke was a separate area outside the town, so to enter the Newarke through this gate visitors had to leave the town by the South Gate. Military drill hall buildings were built adjoining it in 1898, which have since been demolished. It has also been used as a museum of the Leicestershire Regiment.

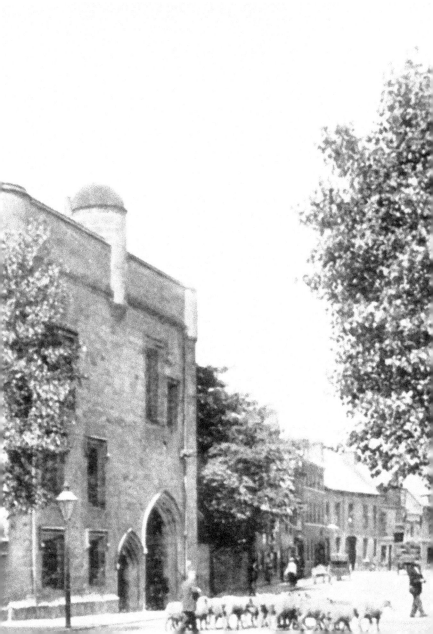

20. THE NEW WALK CENTRE

The two office blocks of the New Walk Centre, built in the 1960s, towered above the nearby older buildings. Built by a speculator who was unable to sell or lease the building as a commercial proposition, it became the headquarters of Leicester City Council until deemed unsafe. It was consequently demolished by controlled explosions in 2015.

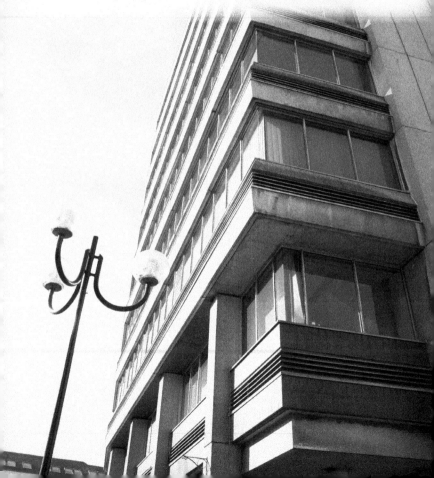

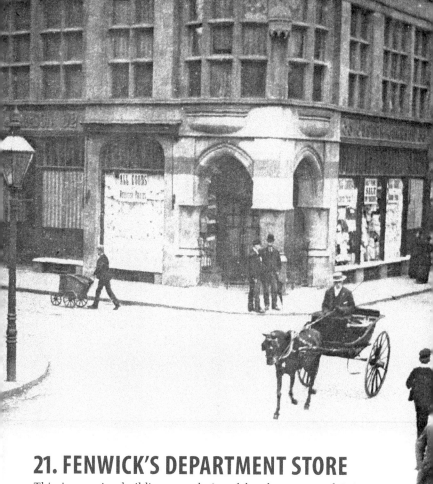

21. FENWICK'S DEPARTMENT STORE

This impressive building was designed by the renowned Leicester Arts and Crafts architect Isaac Barradale for local entrepreneur Joseph Johnson. He owned several different shops and businesses nearby, which he decided to bring under one roof. He ran a funeral service from the basement and accommodated some of his female staff in the roof! The store was acquired by Fenwick's in the 1950s.

22. WYGGESTON HOSPITAL

Wyggeston's Hospital was built in 1519 by William Wyggeston, one of Leicester's greatest benefactors. By the nineteenth century, the building had deteriorated and was in a state of disrepair. In 1875 it was demolished and the Wyggeston Boys' School was erected in its place. After also housing Alderman Newton's School and Leicester Grammar School, these buildings are now the St Martin's Centre of the Diocese of Leicester.

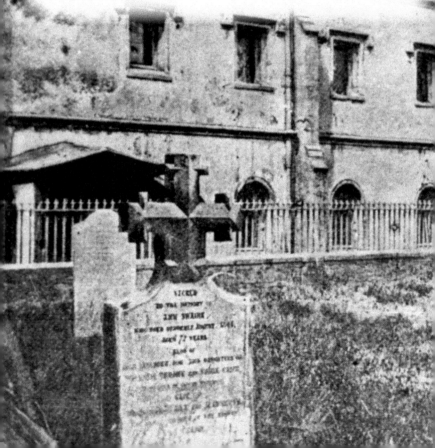

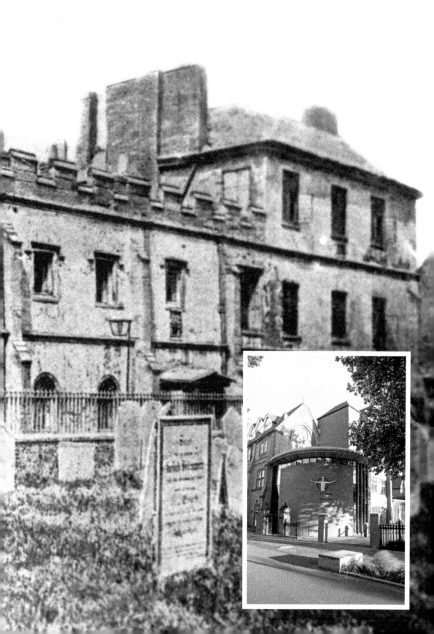

23. LEICESTER CATHEDRAL

St Martin's became a cathedral in 1927, but it has been one of the town's principal churches for more than 700 years. It is said that Cuthwine, Leicester's first bishop, was appointed in AD 679. The last of these early bishops was Ceobred who was consecrated between 839 and 840 and died between 869 and 888, after which Danish incursions led to the see being transferred to Dorchester-on-Thames in Oxfordshire. A tradition asserts that St Martin's was built on the site of a temple dedicated to Diana. Cattle bones were unearthed in 1784 when a grave was being dug between the nave and the chancel.

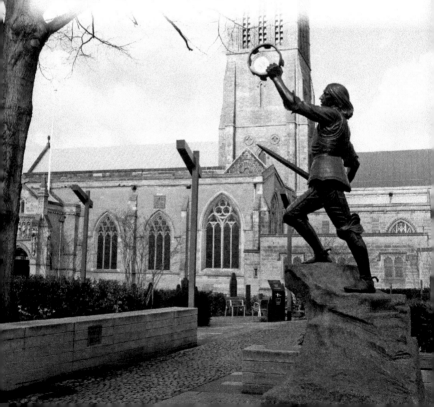

24. BBC RADIO LEICESTER

Beneath part of these modern broadcasting studios lies a Norman undercroft that has been preserved. In Victorian times, a large cheese and wine warehouse was built here for the local company of Swain & Latchmore. In later years this became the well-known Wathes electrical store. The Victorian mosaic tiles along the frontage of the building were rescued by the BBC when the old building was demolished in 2001 and are now part of the interior of the new BBC Leicester broadcasting centre.

25. THE GUILDHALL

The earliest part of the Guildhall was built in around 1390. The Corporation purchased the building in 1563 and used it as the town hall until 1876. It became Leicester's first police station in 1836, and houses the third oldest public library in England, dating from 1632. Here, in the great hall, was the formal public announcement that the remains discovered beneath the nearby Greyfriars were indeed those of Richard III. This is said to be Leicester's most haunted building. Five ghosts have been seen.

26. THE GLOBE INN

A landmark since the eighteenth century, the Globe was a market house used by farmers to recruit workers. It was also once used as accommodation for women facing execution at the nearby gallows. Here, Nathaniel Corah founded his textile business, buying garments from local framework knitters. The pub brewed its own beer for many years using spring water from a well in the cellar. It has been owned by the local Everards Brewery since Victorian times.

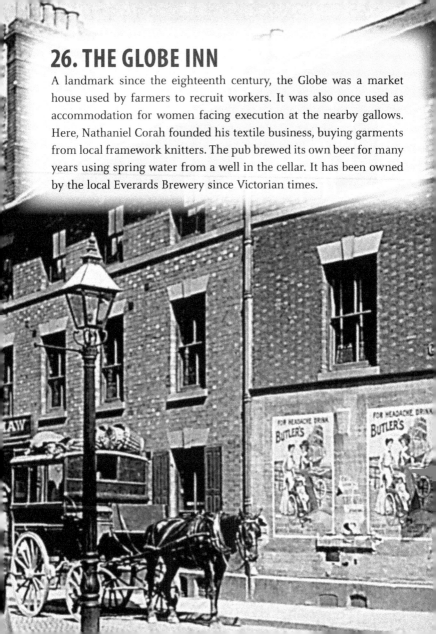

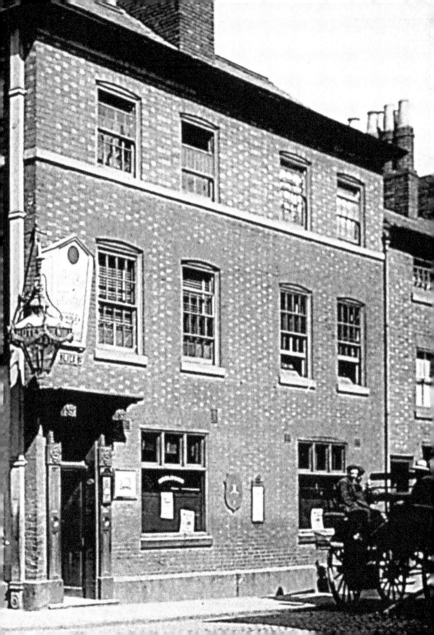

27. HOTEL STREET

Hotel Street is named after the City Rooms, which were built as a hotel but never used as one. The building was designed by John Johnson and opened in 1800 as public assembly rooms. Later, it was sold to the county justices as judges' lodgings during the assizes. Significant alterations were made at the time of the sale as well as to much of the internal decoration, except for the original ballroom dated from this period. It is now a banqueting centre, having been extensively refurbished.

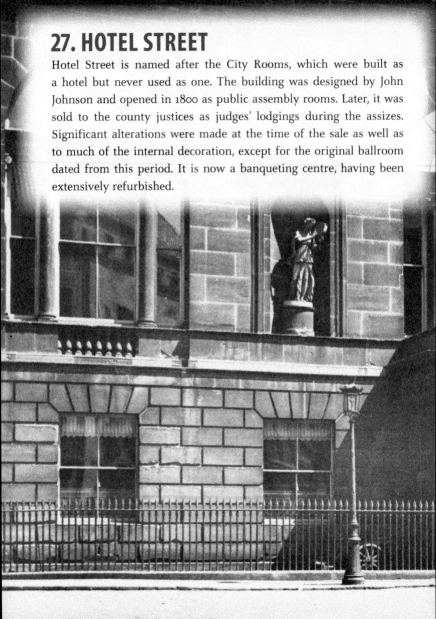

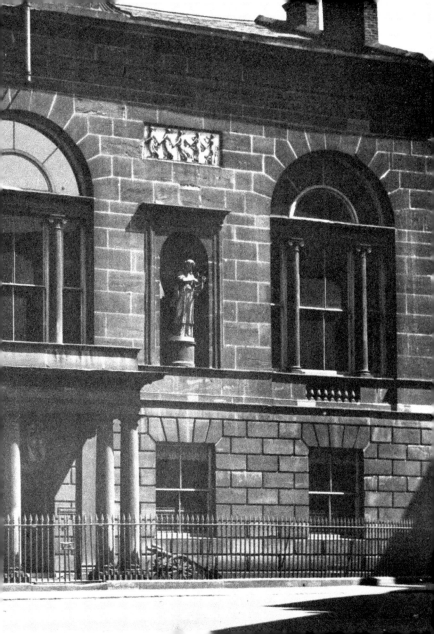

28. THE CORN EXCHANGE

This elegant building was designed by William Flint in the 1850s, with the upper floor and distinctive rusticated open bridge added by F. W. Ordish in 1856. After a fire in the 1980s, the building lay empty for some years. The most recent rebuilding of the indoor market has respected this dignified structure. In the past, political rallies and religious meetings were held in front of the arched bridge.

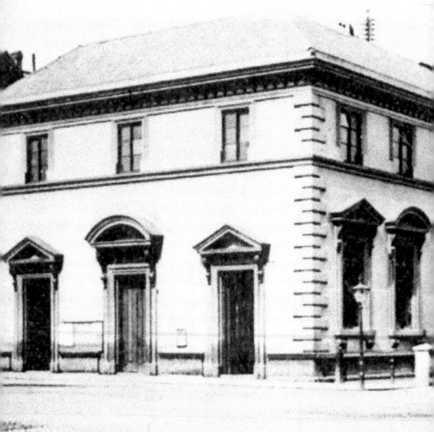

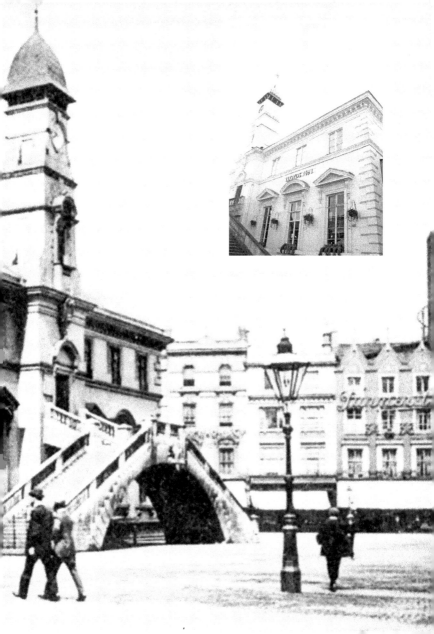

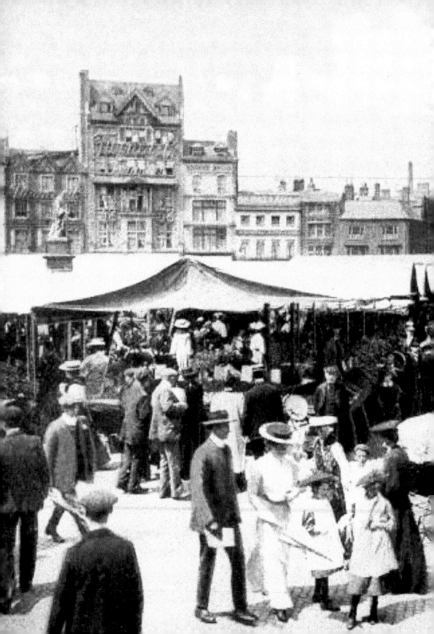

29. LEICESTER MARKET

Formerly the Saturday Market, traders have stood on this site for at least 700 years. It was originally more extensive, with specific areas set aside for selling meat, fish, livestock, horse-drawn carriages and agricultural equipment. Unusually, this market lies in the far south-east corner of the old town rather than at its heart.

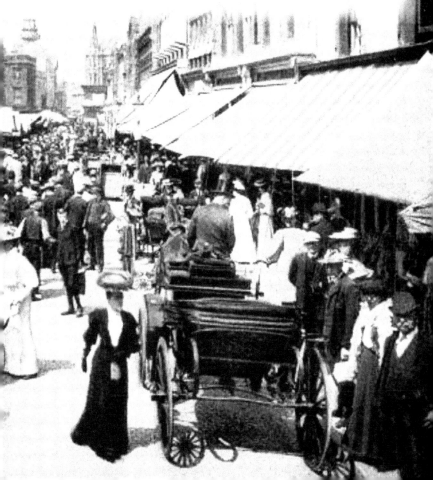

30. STEWARD'S OPTICIANS, GALLOWTREE GATE

Gallowtree Gate was, for many years, busier than the High Street and was where numerous local shops were to be found. Stewards were clearly proud of their association with the Leicester Royal Infirmary. The same premises were used earlier by Charles Foster, a local draper, and later by John Collier, the original 'fifty shilling tailors'.

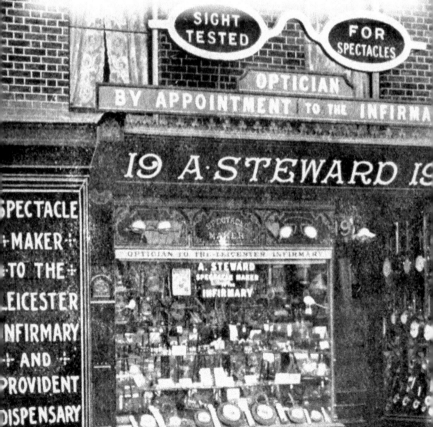

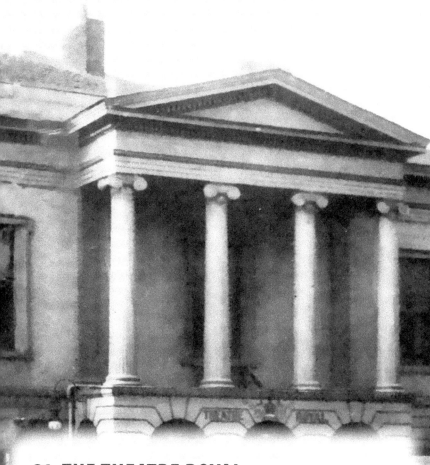

31. THE THEATRE ROYAL

The Theatre Royal occupied a site with its frontage opening onto Horsefair Street, almost opposite Bowling Green Street and the side of the town hall. The stage door was on Market Approach near the Fish Market. It was built in 1836 on the site of an earlier theatre, and for some years was the town's only theatre. It closed in 1958, leaving the city without a major theatre until the Haymarket Theatre opened in 1973.

32. THE TOWN HALL

The town hall is a building of gentle eloquence which, unlike halls in other major cities, stands away from the major roads and public places. It was designed by Frances Hames and constructed between 1874 and 1876. The solid tower placed at the north end of the building, and rising to 145 feet, cleverly disguises the gradient on which the town hall stands. The land was originally Leicester's cattle market.

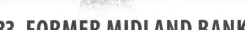

33. FORMER MIDLAND BANK

The former Midland Bank is a spectacular building in red brick and Portland stone with an unusual corner porch and French pavilion roofs. The frontage facing Granby Street is impressive with three tall decorated windows. It was designed by the practice led by the eminent Leicester architect Joseph Goddard in 1870–72 in a remarkable and well-judged blend of Gothic and oriental styles known as Venetian-Gothic. The stained glass is a significant feature of this historic building and has been repaired and restored.

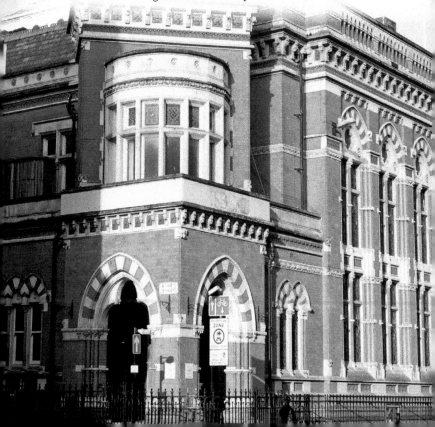

34. THE GRAND HOTEL

On the approach to the city from the south and near the railway station, the Grand was built in 1898 by Cecil Ogden and Amos Hall in 'grand Franco-German Renaissance style reminiscent of the sixteenth century'. Hall added the 'wedding cake' top on the corner of Granby Street and Belvoir Street two years later, influenced by several of Wren's London churches. Winston Churchill stayed here in 1909 and guests at the Leicester Aero Club's ball in 1932 included aviator Amy Johnson.

35. THE LIBERAL CLUB, BISHOP STREET

The Liberal Club was designed by Leicester architect Edward Burgess and completed in 1888 as the headquarters of the Leicester and County Liberal Club. It was also known as the Gladstone Buildings and a portrait bust of Gladstone remains in the lobby. The sculptor was George Saul RA, who lived and worked in Florence. It was the gift of Edwin Clephan JP in 1898. The building was later occupied by the Leicester Building Society and when that society merged to become the Alliance & Leicester, it became Alliance House.

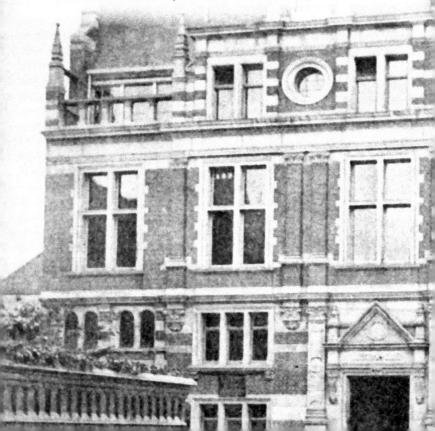

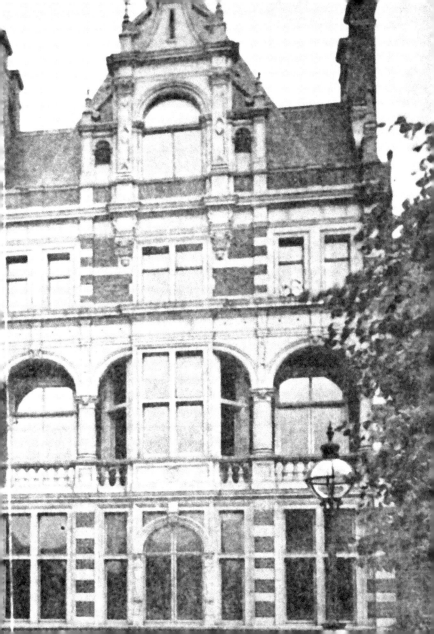

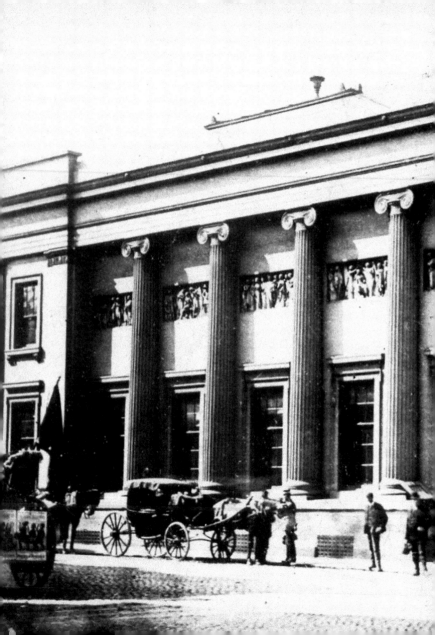

36. GENERAL NEWSROOM, BELVOIR STREET

This imposing building opened in 1837 as a general newsroom and library, designed by local architect William Flint. It was demolished in 1896 as part of 'street improvements'. The present building on the corner of Belvoir Street and Granby Street was built two years later and was certainly impressive in its original form before modern shop fitters replaced the ground floor. It was designed by Goddard and has reliefs of eight of the nine muses along the third storey.

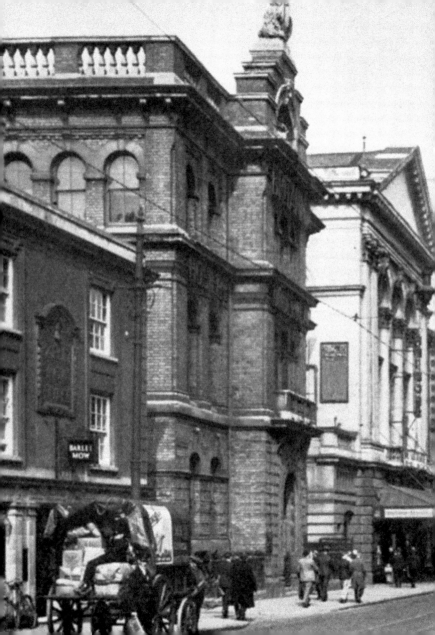

37. GRANBY STREET

By the end of the nineteenth century, Granby Street had become the major gateway to Leicester from the south, its importance marked by fine buildings along the route. The Barley Mow (left) once marked the southern limits of the town. Next door is the Britannia Works and then the Temperance Hall; but other significant buildings were lost when the road was widened in 1898. This view, looking towards the city centre, dates to around 1920.

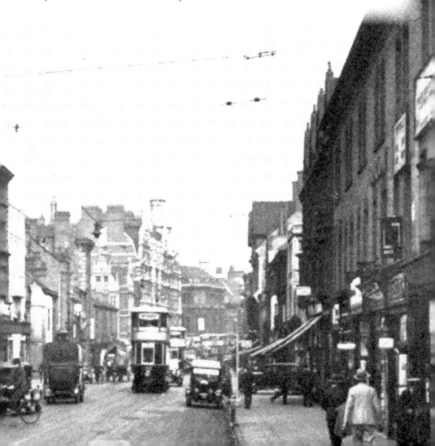

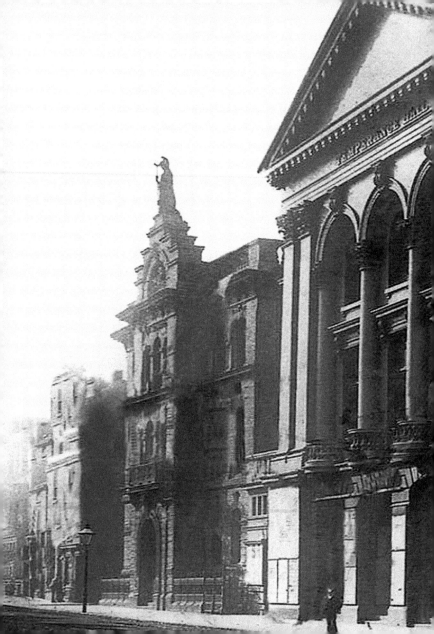

38. THE THOMAS COOK
HOTEL AND HALL

Eleven years after his first railway excursion, Thomas Cook began plans for an impressive Temperance Hall near to the railway station. He added the hotel to his scheme and it was completed before the hall, accommodating a printing facility, tourism offices and residential quarters for Cook and his family. Although the designs were hardly 'modern', these were the first public buildings in Leicester with a piped water supply. The architect for both buildings was James Medland of Gloucester. The hall was demolished in the 1960s, having been used as an Essoldo cinema for many years.

39. THE WYVERN HOTEL

Designed by Arthur Wakerley in the 1890s and opening less than a year after the neighbouring Midland Railway station, this was a Temperance Hotel on a grand scale. St Stephen's Church in New Walk stood on this site but was moved, stone by stone, to make way for its construction. The Wyvern closed in 1933. The building was taken over by Shell-Mex and later British Road Services, but was demolished in 1974 to be replaced by the present Elizabeth House.

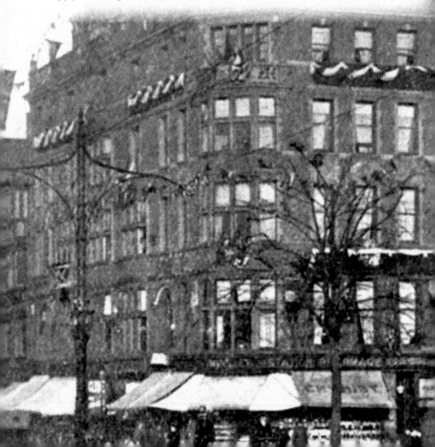

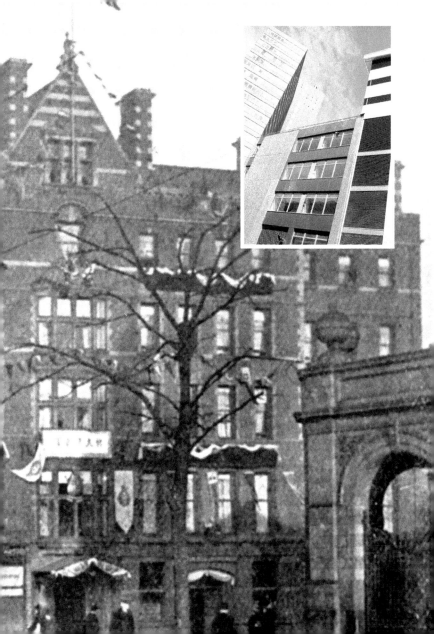

40. CAMPBELL STREET RAILWAY STATION

This was the first station on this site and the most imposing. It was opened on 4 May 1840, a large classical building, eleven bays wide with a giant portico of six Tuscan columns carrying a pediment. It was a truly majestic building, demolished prematurely because of competition between railway companies. At the end of nearby Station Street are two Egyptian-looking gateposts, which are the only surviving features of this amazing structure.

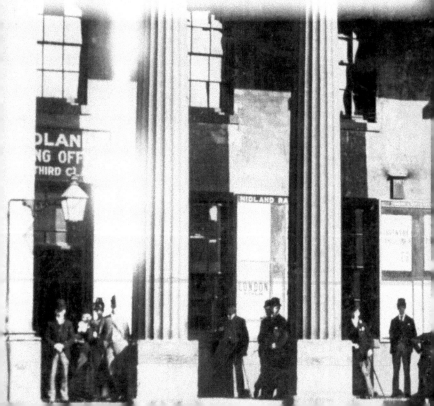

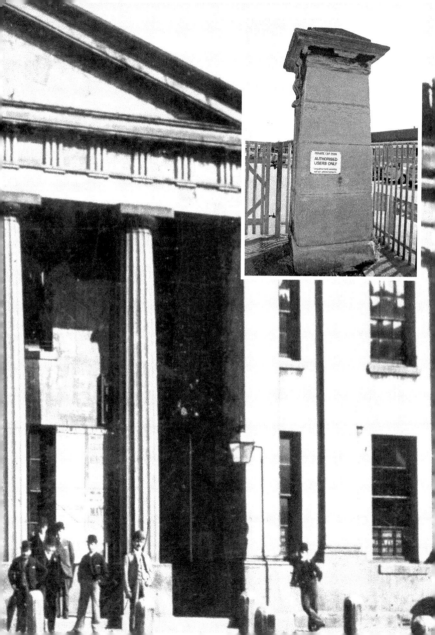

41. LONDON ROAD RAILWAY STATION

Architecturally one of the most welcoming stations on the Midland Railway, London Road Railway Station was designed in 1892 by Charles Trubshaw. Today, its once imposing frontage (the gates were designed and constructed by the local firm of Elgoods) is overshadowed by the high-rise developments of the 1970s. The station clock is the only hand-wound station clock on the British railway network.

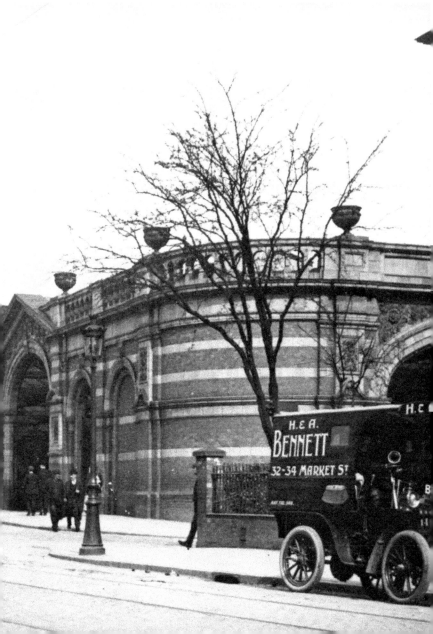

42. CHARLES STREET POLICE STATION

Designed by G. Noel Hill, the station opened on 4 September 1933 as the headquarters of the Leicester City Police. It closed in July 2004 and, following extensive restructuring, is now part of the Colton Square development providing nearly 10,000 square metres of office space. The last chief constable of the Leicester City force (before its merger with the Leicestershire force) was (Sir) Robert Mark who later became commissioner of the Metropolitan Police.

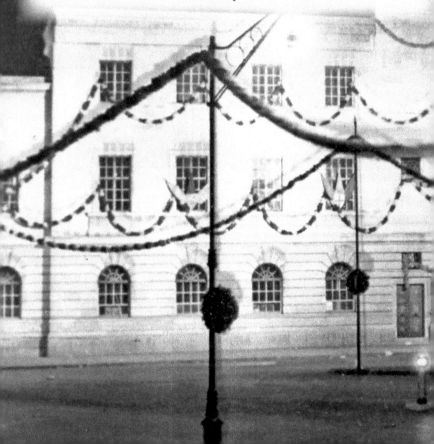

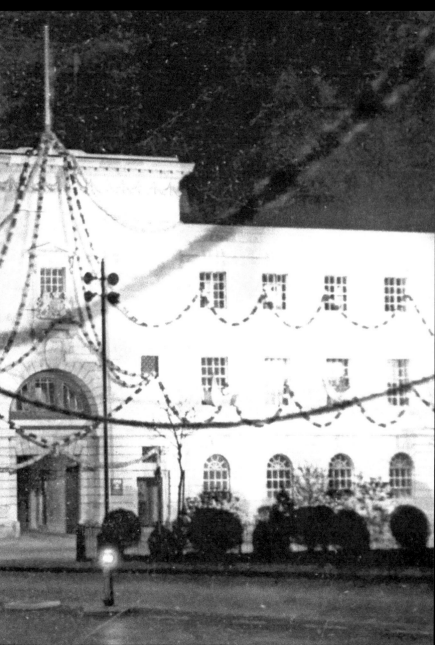

43. ST GEORGE'S CHURCH

St George's was built in local sandstone between 1823 and 1827 to a design by William Parsons and was the first Anglican church to be built in Leicester since the Reformation. The chancel was added in 1879. A fire devastated the church in 1911 and it was largely rebuilt by W. D. Caroe. It is now a place of worship for Serbian Orthodox Christians. The church is now in the centre of a redevelopment area including Leicester's cultural quarter.

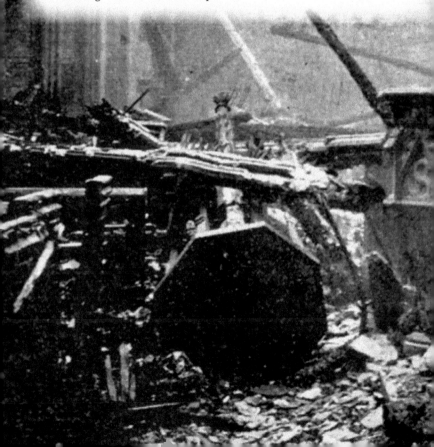

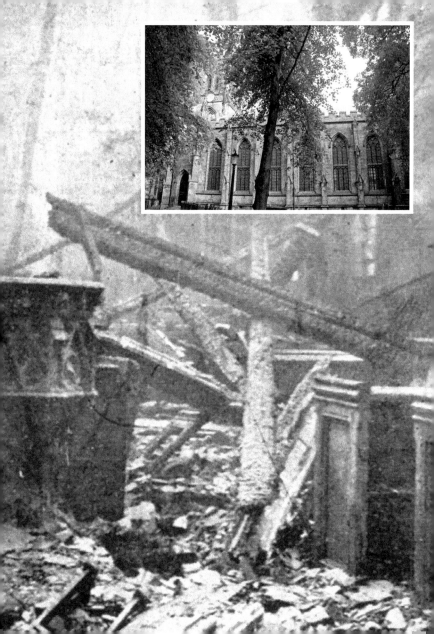

44. ATTENBOROUGH HOUSE

Charles Street was designed as a bypass of the congested clock tower area, and opened in 1932. New buildings, such as Attenborough House, epitomised the confidence and buoyancy of Leicester's economy at the time. The City Council returned here after the demolition of the New Walk Centre following extensive and careful renovation of this significant art deco building. During the Cold War era, the corporation constructed a nuclear bunker in the basement.

45. CLARENCE HOUSE

Edward Burgess designed this building in 1878 as the Wyggeston Hospital Girls School. On the opening day there were 150 pupils taught by four assistant mistresses. The school moved to new premises in Regent Road, the City Boys School moved in from the Great Meeting school building in East Bond Street. In the 1970s, the buildings became redundant. It is said an 'eleventh-hour action' in applying for listed building status prevented their demolition and enabled Age UK to make good use of the premises today.

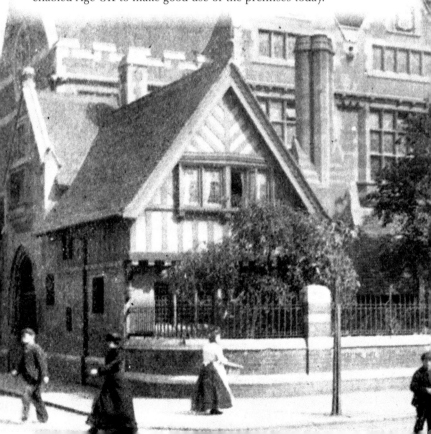

46. THE MEADOWS DISTILLERY

J. Meadows advertised himself as a gin and brandy distiller, but the Midlands Distillery on the corner of Humberstone Gate and Clarence Street was really a wine and spirits warehouse. It was later used by wine merchants Challis & Allen, and by Greens, the electrical retailer. It is still in use today as a retail shop and, after some years of neglect, the impressive Victorian frontage has been refurbished.

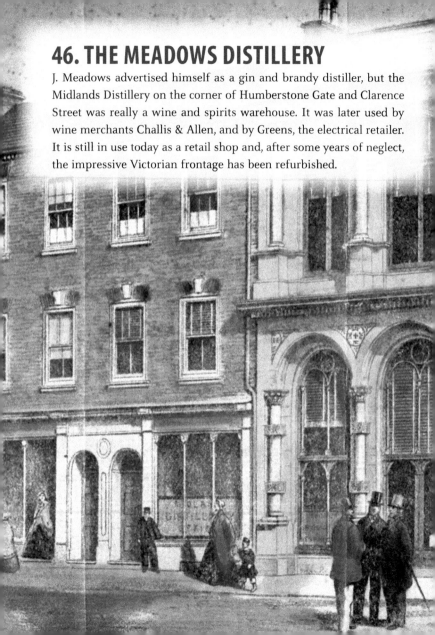

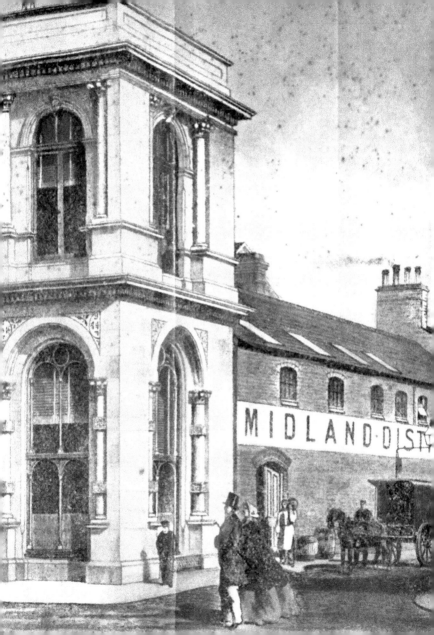

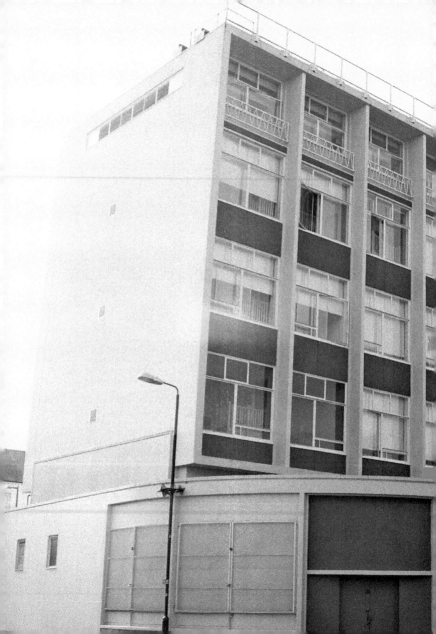

47. THE EXCHANGE, WHARF STREET

For its period and its purpose, The Exchange is a surprisingly elegant and pleasing structure, built as a telephone exchange in the late 1950s. The glazed ground-floor extensions neatly respect the curve of Lee Circle. The architect incorporated into his design the UK's first drive-in post office, but it was never successful.

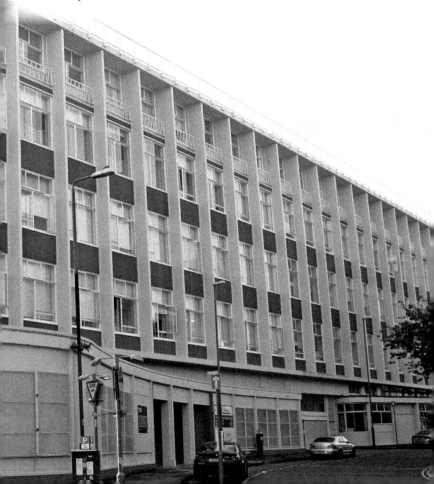

48. THE HIPPODROME, WHARF STREET

In this desolate photograph from 1951, the Hippodrome still looks like a theatre, although very run down. It was built in 1862 as the Gladstone Hotel and Concert Hall, and in its time it served also as a ragged school and an evangelical church. It's most famous owner was Sam Torr who, with colleagues, gave Joseph Merrick, the 'Elephant Man', the chance of a life outside the workhouse. It is likely that Merrick appeared on stage here. By the 1940s, it was a cinema. It fell into disrepair after the war and was eventually demolished in 2009.

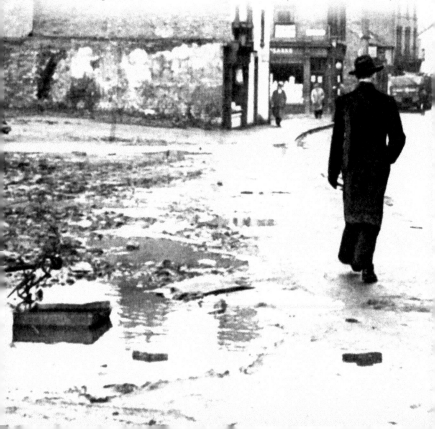

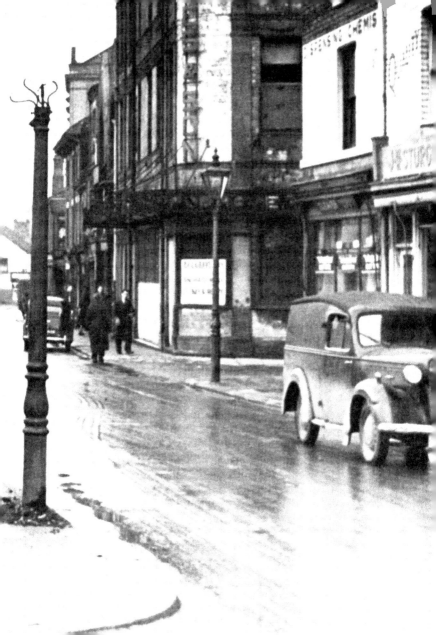

49. NO. 44 WHARF STREET

The view in this photograph is from the front door of the Hippodrome towards the derelict area in the previous image. In this very poor district, families were always on the breadline, the pawn shop next door to the theatre was visited weekly and some shops, such as this butcher, offered free food to local families before Christmas. The side street is Lee Street and it was in the second house on the right – long since demolished – that Joseph Merrick was born.

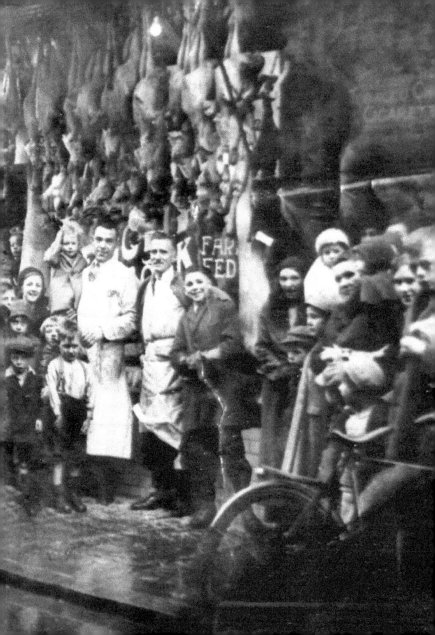

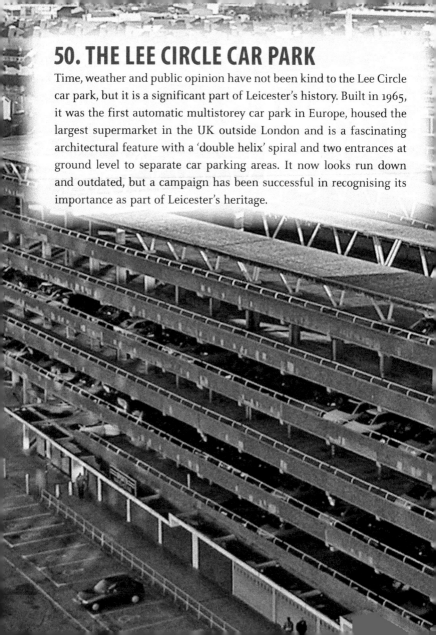

50. THE LEE CIRCLE CAR PARK

Time, weather and public opinion have not been kind to the Lee Circle car park, but it is a significant part of Leicester's history. Built in 1965, it was the first automatic multistorey car park in Europe, housed the largest supermarket in the UK outside London and is a fascinating architectural feature with a 'double helix' spiral and two entrances at ground level to separate car parking areas. It now looks run down and outdated, but a campaign has been successful in recognising its importance as part of Leicester's heritage.

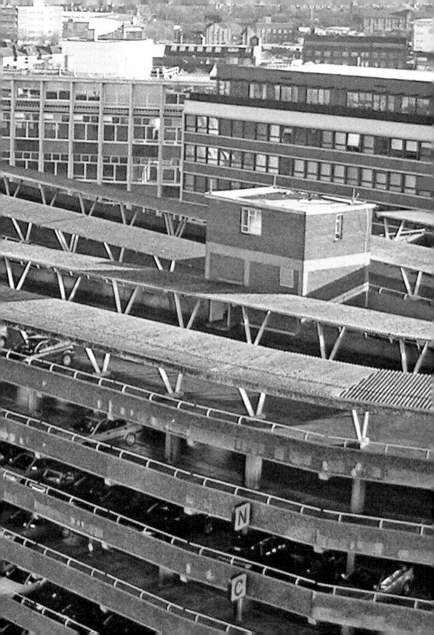

51. HENRY CURRY'S SHOP

As a young man, Henry Curry worked at the St Margaret's Corah factory maintaining the steam engines. There he learned how to weld steel and went on to make bicycles. He was able to open a shop in Belgrave Gate and to move, some years later, to these premises close to the Corah works. Today, Curry's PC World is a household name, familiar on high streets and shopping precincts throughout the UK.

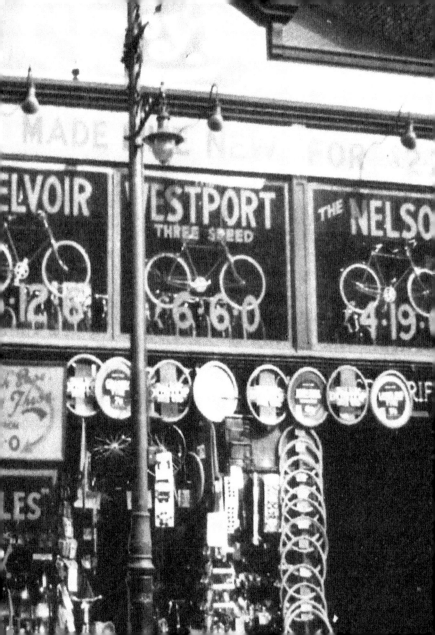

52. ST MARK'S CHURCH

St Mark's was built in 1870–2 to designs by Ewan Christian. The costs were met by W. Perry Herrick of Beaumanor. The church is built of Charnwood slate with the interior lined in red brick. Its most famous vicar was Canon Frederick Lewis Donaldson, described as the 'vicar of the unemployed', who was one of the leaders of the 1905 March of the Leicester Unemployed to London. The building is now used as a restaurant.

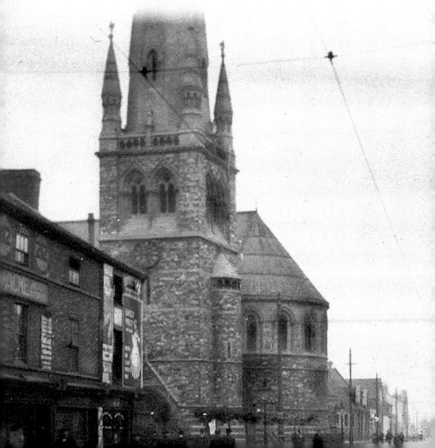

53. EPIC HOUSE

Britain's first mainland local radio station was launched from Epic House when BBC Radio Leicester went on the air from small studios on the eighth floor at 12.45 p.m. on Wednesday 8 November 1967. This office block was opened by radio celebrity Lady Isabel Barnett and stands on the site of the former Horse Repository. A Romano-British cemetery was discovered in the car park prior to the extension of the ground-floor store. Also in a shop on this site, Joseph Merrick in his boyhood worked, rolling cigars.

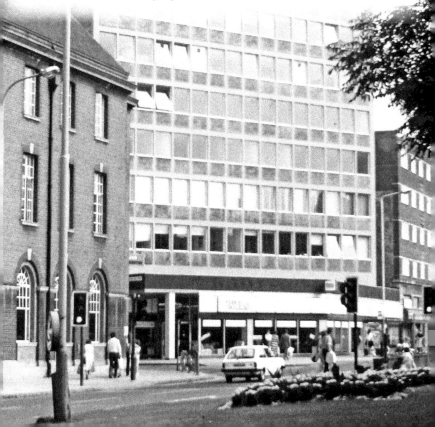

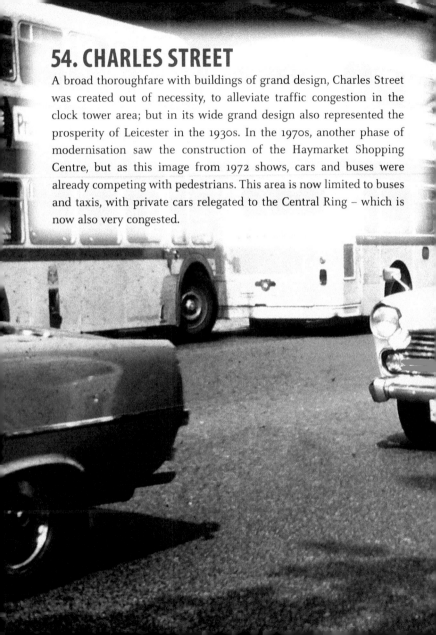

54. CHARLES STREET

A broad thoroughfare with buildings of grand design, Charles Street was created out of necessity, to alleviate traffic congestion in the clock tower area; but in its wide grand design also represented the prosperity of Leicester in the 1930s. In the 1970s, another phase of modernisation saw the construction of the Haymarket Shopping Centre, but as this image from 1972 shows, cars and buses were already competing with pedestrians. This area is now limited to buses and taxis, with private cars relegated to the Central Ring – which is now also very congested.

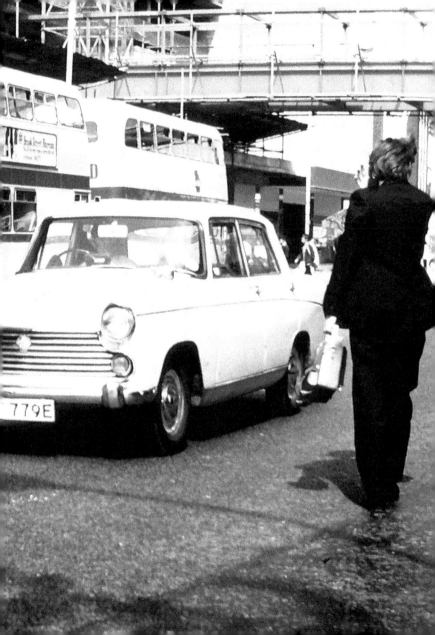

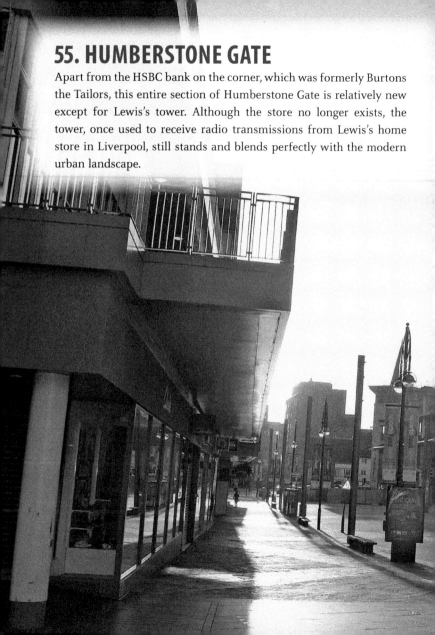

55. HUMBERSTONE GATE

Apart from the HSBC bank on the corner, which was formerly Burtons the Tailors, this entire section of Humberstone Gate is relatively new except for Lewis's tower. Although the store no longer exists, the tower, once used to receive radio transmissions from Lewis's home store in Liverpool, still stands and blends perfectly with the modern urban landscape.

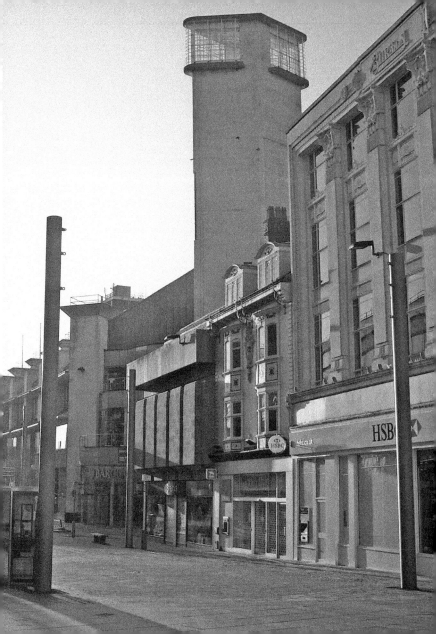

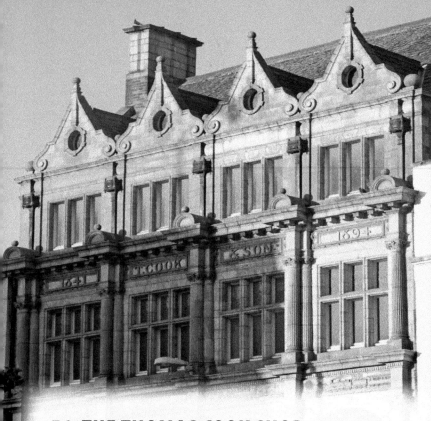

56. THE THOMAS COOK SHOP

The former Thomas Cook office in Gallowtree Gate was designed by Joseph Goddard in 1894. It was built by Thomas's son, John Mason Cook, two years after his father had died, and exemplifies the transition from the philanthropic and charitable concepts of Thomas to the predominantly commercial business aspirations of his son. Above the first-floor windows are four terracotta panels showing major events in the firm's history during Thomas's tenure from 1841 to 1894.